ADOPT
An Educational Coloring Book

Copyright © 2016 by Laurel G. Sira

All rights reserved. This book or any portion thereof may not be reproduced or used in any manner whatsoever without the express written permission of the publisher.

First Edition, March 2016

ISBN: 978-1-329-99083-8

ADOPT
An Educational Coloring Book

by: Laurel Sira

Caitlyn Rack
Illustrative Assistant

Self Published
Athens, Ohio
2016

"My dog does this amazing thing where he just exists and makes my whole life better because of it"

To my mother, who gave me my love of animals and my dog, who gave me my love of life.

Table of Contents

Getting a Dog
Should You Get a Dog?	10
So Why Adopt?	13
Busting the Myth	13
Picking the Right Dog	14

Becoming Part of the Family
First Day	20
Following Weeks	21
Introducing Children to a New Dog	24
Introducing a New Dog to a Resident Dog	26
Introducing a New Dog to a Resident Cat	27

Importance of Spaying & Neutering
Spay and Neuter	32
Busting the Myth	34
Low Cost Spay and Neuter Close to Home	35

Tips for Common Behavior Problems
Barking or Whining	38
Separation Anxiety	38
Begging	39
Jumping Up	41
Playing Too Roughly	41

Resources
Local Resources	44
National Resources	44

Getting a Dog

Should You Get a Dog?

Perhaps you've been toying with the idea of adding a four-legged friend to you family. After all, the unconditional love of a dog has the ability to make our days brighter and our lives better, but adoption is not a decision that should be taken lightly. If you are feeling the pull toward pet parenthood then it's time to ask yourself these questions.

- Do all members of the household want a dog?

- Who will be the primary caretaker, or will the responsibility be shared?
 - If that person goes away for a while (i.e. on a business trip or for any other reason) will other members of the family be willing and able to care for the dog?

- Can you afford a dog right now?
 - Adoption fees, food, toys, training, monthly flea/tick and heart-worm medications, unexpected vet bills, the list goes on and on

- Do you have enough time to devote to the daily needs of a dog?

- Do you plan on moving in the near future?
 - If yes, will you be able to keep the dog?

- Does your apartment allow dogs?
 - Check for age, weight, and breed restrictions

- A dog can live for ten or more years. Are you willing to care for the dog for its entire life?

- If you don't have children, will you still want the dog if you decide to have children?

If you answered yes to all of the questions above then it's time to start looking for the perfect canine companion for your family.

If you have decided that adopting a dog is not the best match for you there are still plenty of things you can do to help; contact your local dog shelter or humane society for a list of opportunities.

So Why Adopt?

There are a million good reasons to consider adopting a shelter dog. Each year, an estimated 6 to 8 million cats and dogs enter shelters and about 50 percent of them are euthanized. But you can make a difference in the life of these animals by choosing a shelter dog. Adoption saves lives.

Busting the Myth

Shelters only have older dogs, and I want a puppy.
 Actually, shelters have pets of all ages. From puppies to seniors, and everything in between, you can find dogs in all stages of life. And remember, while puppies are cute, slightly older dogs may already be house-trained and easier to handle.

I'm in love with a certain breed and shelters only have mixed-breed dogs.
 Not true! The National Council of Pet Population Study and Policy estimates that 25 percent of dogs in shelters are purebred. It may just be a matter of searching shelters in your area.

If a dog's been abandoned, there must be something wrong with him.
 Dogs are given up for all kinds of reasons. In truth, the majority of dogs who end up in shelters end up there through no fault of their own. Some owners have a change in life circumstances that prevent them from keeping a dog; some owners pass away and leave no one to care for their pet; and unfortunately some owners are just not cut out to be pet parents in the first place. Visit your local shelter and you'll be amazed by the well-trained, loving, fabulous dogs you'll find there.

Shelter staff won't be able to find the right dog for my family.
 Hard-working shelter staff spend lots of time with the animals in their care. Most of them are experienced with adoption "matchmaking". After all, the last thing they'd want to see is a dog who gets sent back after being placed. It would just be too heartbreaking! That's why they'll carefully screen you to find out what kind of dog will suit you best.

Picking the Right Dog

So now that you have decided that adoption is the right choice for you, it is time to pick a dog. Deciding what kind of dog to get is as important as deciding whether to get a dog in the first place. Every breed has its own unique temperament, appearance, activity level and set of needs. You should do some serious and careful research to determine which breed of dog is right for you and your family. Here are some things to consider:

Temperament
You're going to be living with this dog for a long time, so you need to make sure he has a personality you can live with. Do you want a dog that is active, or subdued? A dog that is easily trained, or strong-willed? A dog that is friendly to everyone he meets, or one that is loyal to family but aloof toward strangers?

Size
All little puppies are adorable, of course, but they grow quickly, and some of them grow a lot. It's important to find out how large that cute puppy will become before you bring it home. Remember that larger dogs require more food and space.

Coat/Grooming Needs
All dogs need to be groomed regularly to stay healthy and clean; most dogs will shed. But some dogs shed profusely all year round; some shed in clumps for a few weeks; some dogs shed only a little bit. Long-coated dogs are beautiful to look at, but require a lot of effort to stay that way. Short-coated dogs are easier to care for, but may still shed, and may require protection in cold or wet weather. Dogs with fancy trims may need professional grooming. Decide how much dog hair you're willing to put up with, and how much time and energy you can spend on grooming, when you're deciding which breed is right for you.

Male or Female

In general, there is no significant difference in temperament between male and female dogs. If you are getting a dog for a pet, you will want to have your dog spayed or neutered, which will eliminate most minor differences anyway.

Puppy or Adult

The advantage of getting a puppy, aside from its irresistible cuteness, is that you can raise it yourself from the beginning, and participate in its training and socialization every step of the way. The disadvantage is that training a puppy requires a great deal of time and patience. Busy families should keep in mind that puppies cannot be left alone for more than a few hours at a time. They need plenty of trips outside, frequent meals, and lots of interaction with people. Adult dogs can be ideal for people who want a dog with fewer needs. Mature dogs tend to be calmer; some are already house-trained and know some basic obedience.

I would recommend sitting down with your family and making a list of the traits that you would like in your new dog. Be sure to bring that list to the shelter with you when you go. Doing so will keep you from falling into puppy love and bringing home the wrong dog.

Becoming Part of the Family

Before You Bring Your Dog Home

This can be a very exciting time for you and your family, but often can be confusing and stressful for your dog. To help make the transition as smooth as possible consider the steps below.

Dog-proof the area where your pooch will spend most of his time during the first few months. This may mean taping loose electrical cords to baseboards; storing household chemicals on high shelves; removing plants, rugs, and breakables and installing baby gates.

If you plan on crate training your dog, be sure to have a crate set-up and ready to go when you bring your new dog home.

Training your dog will start the first moment you have him. Take time to create a vocabulary list everyone will use when giving your dog directions. This will help prevent confusion and help your dog learn his commands faster.

Bring an ID tag with your phone number on it with you when you pick up your dog so that he has an extra measure of safety for the ride home and the first few uneasy days.

First Day

When you pick up your dog, remember to ask what and when he was fed. Replicate that schedule for at least the first few days to avoid gastric distress. If you wish to switch to a different brand of dog food, do so over a period of several weeks.

Once home, take the dog to their toileting area immediately and spend a good amount of time with him so he will get used to the area. Remember, coming into a new home with new people, new smells and new sounds can throw even the best housebroken dog off-track, so be ready just in case.

If you plan on crate training your dog, leave the crate open so that he can go in whenever he feels like it in case he gets overwhelmed. The crate should become the dog's safe place.

Give your dog time to acclimate to your home and family before introducing him to others, such as friends or neighbors.

Following Weeks

People often say they didn't see their dog's true personality until several weeks after adoption. Your dog may be a bit uneasy at first as he gets to know you. Be patient and understanding while also keeping to the schedule you intend to maintain for feeding, walks, etc. This schedule will show your dog what is expected of him as well as what he can expect from you.

After your veterinarian ensures your dog has all the necessary vaccines, you may wish to take your dog to group training classes or the dog park. Pay close attention to your dog's body language to be sure he's having a good time.

If you encounter behavior issues that you are unable to resolve, ask your veterinarian for a trainer recommendation. Select a trainer who uses positive-reinforcement techniques to help you and your dog overcome these behavior obstacles.

Introducing Children to a New Dog

Kids and dogs have a lot in common: they're inquisitive, impatient, and easily excited! This is why it's important to carefully supervise first encounters between a new dog and your children.

Until you're sure that the dog and the child know how to behave around each other, you should always be present. Stay in the background, but be observant and ready to step in if a situation looks like it's going wrong.

Let the dog approach the children, not the other way around. This can be very hard for children to understand. They can get excited when they see a dog and want to rush up and start petting it, which can provoke anxiety in the dog leading to a negative reaction.

Become familiar with canine body language. You and your children should learn to recognize when there are signs of dominance or aggression, and end the interaction immediately.

Model the way that you want your children to approach the new dog. Once they learn this at home, they'll understand the safe way to approach dogs they do not know (with the owner's permission, of course).

Have your children help you take care of the new dog. Having a dog is a great way to teach them about responsibility. Children can also help take part in training. Both children and dogs learn by doing.

Introducing a New Dog to a Resident Dog

Just like with people, first impressions are also very important to dogs. How the dogs interact in their first few encounters can set the tone for their entire relationship, so make sure that you follow these steps to make those first encounters successful.

> Have the dogs meet on neutral territory first: this can be a neighbor's yard, a training center, tennis court, etc. Have both dogs on-leash. Allow them to look at and sniff one another through a barrier, such as a fence, for up to 30 minutes. The idea is simply to acclimate them to each other's presence without causing tension.

> Next, have the dogs meet off-leash on neutral territory. Avoid problem areas like gates, doorways or closely confined space: the more room they have to move, the less tension there will be. Wait 2 minutes while they sniff each other, then call them away and move around. If they start to play and it seems to be going well, let them play for a few minutes and then end the session. We want each initial interaction to end on a good note!

> Finally, have the dogs meet at home: first in the yard, then inside the house. Before the in-house introduction, take the resident dog out to the yard, then bring the new dog inside (bringing the new dog inside to meet the resident dog can create a negative reaction). Keep each interaction short and pleasant: if signs of tension arise, separate the dogs immediately and try again later.

> Keep the dogs separate while you are away, either in separate rooms or crates. This is both to prevent fights and the development of inappropriate behavior in your new dog (such as chewing or house soiling).

Introducing a New Dog to a Resident Cat

Despite the stereotype of "fighting like cats and dogs," many adopted dogs learn to live peacefully with their cat counterparts. The most important thing for adopters to know is that this adjustment is a process, not a one-time introduction.

Keep the pets separate for at least the first 3-4 days. The goal is to allow the pets to get used to each other's presence without face-to-face contact. Even if they can't see each other, they can hear and smell each other.

While the pets are still separate, begin to feed them on opposite sides of a closed door. The idea is to teach them to associate the presence of the other pet with pleasant things, such as food.

When the pets can eat their food calmly right next to the door, begin face-to-face meetings. Keep the first few sessions short and calm. Keep the dog on a leash and let the cat come and go as it wishes.

Repeat these face-to-face sessions daily, saving the pets' favorite treats for when they are together. If the cat attempts to leave the room, allow her to do so, and do not let the dog chase her. Try to end each session before either pet shows stress or aggression.

When both animals appear to be getting along well, allow them loose in the room together. If tension erupts between them, go back to the earlier introduction steps and repeat the process.

Make sure the cat has access to a dog-proofed sanctuary at all times, complete with a litter box.

Importance of Spaying & Neutering

Spay and Neuter

Every year millions of unwanted dogs and cats are euthanized. The good news is that responsible pet owners can make a difference. By sterilizing your dog you will be helping to prevent unwanted litters. You will also be helping to protect your best friend against some serious health problems, and it may reduce many of the behavioral problems associated with mating instincts as well.

Benefits of Neutering (males)
 Reduces or eliminates risk of spraying and marking
 Lessens the desire to roam
 Eliminates the risk of testicular cancer
 Decreases incidence of prostate disease
 Reduces number of unwanted dogs/puppies
 Decreases aggressive behavior
 Helps dogs live longer, healthier lives

Benefits of Spaying (females)
 Eliminates heat cycles
 Reduces the risk of mammary gland tumors, and ovarian cancer
 Eliminates the risk uterine cancer
 Reduces number of unwanted dogs/puppies
 Helps dogs live longer, healthier lives

Additional Benefits
 Your community will also benefit. Unwanted animals are becoming a very real concern in many places. Stray animals can easily become a public nuisance, soiling parks and streets, ruining shrubbery, frightening children and elderly people, creating noise and other disturbances, causing automobile accidents, and sometimes even killing livestock or other pets.

Busting the Myth

Female dogs should have at least one litter before being spayed.
There is no medical evidence to justify allowing a dog or cat to have a litter before spaying.

Animals become less active and overweight as a result of spaying or neutering.
Animals become overweight only when they are fed too much and not exercised properly.

Behavior is adversely affected by sterilization.
The only changes in a dog's behavior after spaying or neutering are positive changes.

Spaying and neutering is painful to my dog or cat.
Surgical sterilization is performed under general anesthesia by a vet. The procedure itself is not felt by the patient. There may be mild discomfort after the surgery, but most animals return to normal activity within 24 to 72 hours.

Children should be allowed to witness the miracle of birth.
Most dogs and cats have their litters at night in quiet, dark places far out of anyone's sight. Every litter of puppies and kittens born contributes to the thousands of unwanted dogs and cats who die every day across America in our nation's pounds and animal shelters.

Spaying and neutering are expensive.
The cost of sterilization varies greatly from one place to another. Many communities offer free or low-cost sterilization for those who cannot afford it.

Low Cost Spay and Neuter Close to Home

There are several groups in the surrounding area that host low cost spay and neuter clinics.

Project Neuter Spay
Project Neuter Spay hosts mobile clinics in Athens County. Go to their Facebook page "Project Neuter Spay - Athens, Ohio", for more information.
https://www.facebook.com/Project-Neuter-Spay-Athens-Ohio-155272521297776/

Athens County Humane Society
The Humane Society also hosts mobile clinics in Athens County on the first Thursday of each month. Go to their website for more information.
http://www.athenshumane.org/spay-neuter/

The Humane Society of Parkersburg
Parkersburg Human Society has opened a low-cost spay/neuter clinic (the SPOT clinic) that operates 5 days a week. Go to their website for more information.
http://www.hsop.org/SpayNeuterServices/LowCostSpayNeuterClinic

In Hocking County
The Pet Orphanage is located in Logan, and is dedicated to helping end pet overpopulation through sponsoring cat and dog spay/neuter clinics, administering spay/neuter grants and through education. Go to their website for more information.
http://thepetorphanage.org/

Tips for Common Behavior Problems

It Happens...

Sometimes even the best trained dogs can forget their manners, while other dogs were simply never trained. If your dog begins to exhibit a problem behavior, try to work on correcting it right away. The longer you let it go on, the harder it will be to correct.

The following are some common problems, as well as ways to help manage them:

Barking or Whining

The first thing to remember about barking is that it's natural and, for many dogs, it's quite enjoyable. For your part, when barking or whining aggravates you, try really hard not to "bark" or whine back. The message he gets from you "barking back" is that maybe he should be louder, or maybe he should repeat himself so that you stop. Instead, teach your dog to bark on command using the words "speak" or "bark," and to be quiet on command using the words "shush" or "quiet." It's usually easier to teach "speak" first, while your dog is actually barking. Simply encourage him by saying "good speak." Feeding him will necessitate that he stop barking to chew and swallow. When he is finally quiet, say "good shush," and reward him again.

Separation Anxiety

To combat this reaction, acclimate your dog to your comings and goings by starting small and making the experience a positive one. Without making a big fuss over it, decide to leave the house. Put your dog in his crate or a confinement room with a favorite chew toy, turn the radio on to a classical or soft rock station (something soothing) and, without saying another word, pick up your coat, bag, and car keys and pretend to leave the house. Walk around

the house quietly, listening to or spying on your dog without him knowing. Give him a couple of minutes, depending on whether he gets upset when you leave or not. If he does get upset, allow him some time to settle down. (A really appealing chew toy given on your way out should be enough; if it's not, find something more appealing.) If he doesn't get upset but settles right in with the chew toy, give a silent cheer.

When your dog is quiet and you've been out more than five minutes, come back in as if nothing has happened, put your things down, and quietly and calmly greet your dog. Do not run to him and smother him with kisses. Put on his leash and bring him outside, just as you would if you were returning from a longer trip. Let him learn that you come home and take care of his needs. Do this a few times a day in the first days and weeks, increasing the amount of time you are gone from the house.

Begging

This is a bad habit that is easier to prevent than to cure, so from the very beginning, when it's time for you to eat, put your dog in his crate or confine him in a room with an engaging chew toy to occupy him. Only let him out when you're finished. If you want to feed him leftovers, put them in his food bowl and incorporate them into regular meals.

If you have a beggar, start crating or confining him. Prepare yourself and your family to suffer through the barking and whining for as long as it takes. Only release him from the confinement when he is quiet.

Jumping Up

Your dog can't jump up on someone if he's sitting down, lying down, or otherwise confined. Enlist a friend or neighbor, as well as other family members, to help redirect this behavior. Put your dog on a leash, have someone ring the doorbell, approach with your dog, and ask the dog to sit. When the dog sits, open the door. If he doesn't sit, wait until he does. When the person enters have them ask the dog to sit, and reward him. He sits, he gets a treat, if he doesn't sit, the person should turn their back on him for a moment. Make sure he doesn't jump up by holding his leash. Ask him to sit first, and be sure he does. Then the person should turn around and ask him to sit, too. Repeat until the dog complies.

Playing Too Roughly

It's critical that rough play be settled and stopped immediately. To settle your dog when he's playing this way with you, stop moving or making sounds. Stand up if you're on the floor. Keep your hands and arms close to your body. Be a statue if possible, even if the dog is jumping up on you. If he is playing with others this way, have them stop moving and get up slowly, paying no attention to the dog.

And Remember...

Not all problems can be solved on your own. If you have tried to correct a behavior with unsuccessful results contact a professional trainer for help!

Resources

Local Resources

For more information about this book, or project Adopt go to: *http://www.adopt-coloringbook.com*

For more information about Friends of the Shelter Dogs in Athens, and ways to help, visit: *http://www.fosdathens.com* or *https://www.facebook.com/athensfosd*

To see a current list of dogs available at the Athens dog shelter go to: *https://www.petfinder.com/pet-search?shelterid=OH27*

For information from the Athens Humane Society or to report a case of animal abuse or neglect visit their site at: *http://www.athenshumane.org*

Check out New Beginnings Animal Center at: *https://www.facebook.com/NewBeginningsAnimalCenter/info/?tab=overview*

National Resources

Looking to adopt a specific breed, gender, age, etc. check out: https://www.petfinder.com

For all kinds of tips and training advice go to: *https://www.cesarsway.com*

If you looking for ways to help shelter pets nation wide, visit: *http://theshelterpetproject.org*

For questions regarding your dog's health go to: *http://www.pethealthnetwork.com/dog-health*

For information on almost any breed look *at: http://www.dogresources.com*

Express Yourself

Please feel free to use these last few pages to express yourself. You can write down your adoption story, add additional information and resources, or simply draw a picture. This space is all yours, go crazy!

www.ingramcontent.com/pod-product-compliance
Lightning Source LLC
Chambersburg PA
CBHW080849170526
45158CB00009B/2683